VERTIGO

A NOVEL IN WOODCUTS

LYND WARD

With an Introduction by
DAVID A. BERONÄ

DOVER PUBLICATIONS, INC.
Mineola, New York

Bibliographical Note

This Dover edition, first published in 2009, is an unabridged republication of the work originally published in 1937 by Random House, New York. The blank pages backing up the woodcut illustrations have been eliminated for space considerations. A new Introduction by David A. Beronä has been specially prepared for this Dover edition.

Library of Congress Cataloging-in-Publication Data

Ward, Lynd, 1905–1985.
 Vertigo : a novel in woodcuts / Lynd Ward ; with an introduction by David A. Beronä. — Dover ed.
 p. cm.
 Originally published: New York : Random House, 1937. With new introd.
 ISBN-13: 978-0-486-46889-1
 ISBN-10: 0-486-46889-5
 1. Ward, Lynd, 1905–1985. 2. Stories without words. 3. Graphic novels—United States. I. Title.

NE1215.W37A4 2009
769.92—dc22

2008051095

Manufactured in the United States by LSC Communications
46889504 2017
www.doverpublications.com

Introduction to the Dover Edition

The success of Lynd Ward's first woodcut novel, *Gods' Man,* which sold over 20,000 copies in six printings over four years, waned with each of the following five wordless books that he published between 1930 and 1937. After *Madman's Drum* (1930) and *Wild Pilgrimage* (1932), Ward completed two shorter "pictorial narratives," his preferred description for his wordless books, before publishing *Vertigo* in 1937. His shorter works were *Prelude to a Million Years* (1933), which addressed the social and spiritual isolation and despair of an artist who lives for his art alone, and *Song Without Words* (1936), centering on a mother's haunting fears of bringing a child into a world that she envisions as being full of pain and suffering.

Despite the cautious attitude of publishers in the midst of the Depression era, as well as Ward's growing commitment as a children's book illustrator, he continued in his belief that his pictorial narratives were the best means for him not only to showcase his skill as an artist but also to offer his personal and humanistic ideas. Although Ward's wordless books lost their novelty with a reading public, the editors at Random House recognized the social impact and importance of *Vertigo.* They published this colossal book of 230 prints, which took Ward two years to complete and is considered his masterpiece. It has remained out of print for over seventy years. Ironically, the sentiments and events documented by Ward in *Vertigo* have as much relevance today in our national recession with an unstable stock market, shortage of jobs, foreclosures, mistrust of authority, and general hopelessness in the future.

In *Vertigo,* Ward put faces to the startling numbers of men and women who experienced unemployment, debt, and poverty during the Great Depression and displays in pictures what Edward Newhouse *(You Can't Sleep Here)* and Jack Conroy *(The Disinherited)*

were writing about at the time. The title *Vertigo,* Ward later explained, "was meant to suggest that the illogic of what we saw happening all around us in the thirties was enough to set the mind spinning through space and the emotions hurtling from great hope to the depths of despair."

Vertigo tells the story of three characters, referred to in the chapter headings as The Girl, The Boy, and An Elderly Gentleman. The book begins with the girl and boy graduating from high school. The girl has a dream of becoming a concert violinist, and the boy hopes to work in the building trades. The two soon are faced with the economic realities following the stock market crash of 1929. The boy moves away from the city to find work so that the couple can get married, but returns unable to secure a job and embarrassed to admit defeat to the girl, who has endured her own personal tragedy: her father loses his job and fails in a suicide attempt, resulting in his blindness. In contrast to the boy and girl, Ward presents the elderly gentleman, who is isolated from the realities around him. In order to curb his business losses, he instructs his managers and factory bosses to fire employees and make greater demands on the remaining workers. His power stretches into the highest-ranking government officials, and he is able to enlist the National Guard to put down labor strikes with force. However, his health is failing, and his doctor pays the boy for a blood transfusion, which seems to drain the spirit from the desperate young man. This provides the boy money to reunite with the girl, but there is no happy ending. Rather, Ward depicts a frightful scene with the couple on a roller-coaster car. The girl's head is buried in the boy's chest; he stares in shock as the car falls speedily down the track. In his previous pictorial narrative, *Song Without Words,* Ward offered hope in the final illustration of a united family. In *Vertigo,* Ward's hope for the future has diminished.

This pictorial drama about three people whose lives intersect is told in a manner that encourages the reader to flip back through the book as the characters weave in and out of each other's lives. Ward was challenged with the woodcut form in presenting the experience of the Great Depression, feeling that "this problem of basic composition was more difficult for *Vertigo* than for any of my other books." He refrains from using page numbers, breaking down each of the three parts into chapters that indicate shorter units of time as the characters' lives overlap. The girl's life is broken up with events in chapters

labeled with the years 1929 to 1935. The elderly gentleman is portrayed during the months of a single year. And the boy's life is broken up into the days of a week. This device successfully pulls us back in a linear timeline as events unfold in the characters' lives.

Ward also opened up the borders of his woodblocks so that his prints became more dynamic, allowing the action to bleed out to the edges. In addition, he opened white space around objects so that the static borders of the prints were no longer displayed—a comparison of the prints in *Vertigo* to any of his other wordless books makes this clear. Ward also expanded his use of various print dimensions on the page, bringing the reader closer to characters and focusing attention on specific objects. This is clearly demonstrated, for example, in the small blocks (2-x-2 inches) he uses to depict the board members delivering advice to the elderly gentleman to remedy the dramatic fall in company revenue. The small dimensions of these prints convey the lack of individuality of the board members. Except for the character with a moustache, the men all look the same—stereotypically overweight, balding businessmen in suits and ties. Ward furthermore directs our attention to the facial expressions of the board members, revealing panic and underhanded scheming, as well as mannerisms such as pointing a finger of warning or pounding a fist for immediate action.

Beyond Ward's narrative skill, what cannot be overlooked in *Vertigo* is his accomplished wood-engraving technique, which he improved throughout his previous books. The detail Ward achieves in his prints is astonishing; his mastery is displayed, for example, in the crisp lines that segment the action dynamically in the thunderstorm at the park, in his use of white space to successfully encapsulate a moment or event like the girl kissing the boy after he presents her with an engagement ring, and in the disturbing complexity of light and shadows that he displays in the dark corners of the city. Each print deserves a moment of appreciation for its skilled workmanship in addition to its narrative importance.

Ward was a purist in both his storytelling and artistic techniques. He discarded blocks with even minor imperfections, as well as those that he felt were no longer necessary to the narrative. Ward estimated that in the ten years since he had worked on *Gods' Man*, he had engraved over 800 blocks. The wood blocks created for *Vertigo* are part of the Special Collection at Rutgers University. A 2003 exhibit of these blocks, curated by Michel Joseph, not only displayed the

intricacies of Ward's accomplished engraving but also included blocks he suppressed from the book; these blocks, notes Joseph in the catalogue to the exhibit, are "unique artifacts [that] provide a wealth of information about subplots that Ward discarded."

Ward also increases his use of symbols in *Vertigo*, such as a rose that is regarded as an aesthetic ideal, though with different connotations, in the hands of the girl and the elderly gentleman—the girl sees creative beauty, whereas the elderly gentleman perceives a commodity. The use of trains and telephones, beyond the literal interpretation as means of travel and communication, are also used as metaphors in various scenes. For those who can afford the luxury, like the elderly gentleman, the train offers escape from the cold winter and realities suffered by many families left homeless and hungry. The telephone provides the elderly gentleman with the means of rapid, impersonal communication, which he uses to organize an armed police force to bust a union strike. In contrast, for the boy, the train is an unwelcoming means of travel—he is forced to jump on a train and ride illegally on the top of a boxcar. The telephone is an unaffordable communication device that further isolates the boy. There is a poignant print of the boy walking in a desolate countryside under giant telephone poles—the telephone lines illuminate with activity as they appear like a spider's web over his figure. One bright star looms in the horizon, further highlighting the boy's alienation in the modern technological maze.

Another noteworthy feature of *Vertigo* is Ward's use of text in signs and labels, providing further insight into the characters and events. When the boy finally finds work at Bugg's dress shop, he comes into contact with strikers holding a sign reading "Strike Against Bugg." Seeing this, and unwilling to cross the picket line, the boy leaves the only job he could find. This particular event reflects a personal belief of Ward's—he was an adamant union supporter (as were all the Wards)—given that his father was Dr. Harry F. Ward, a Methodist minister, writer, and outspoken commentator on social activism, and the first board chairman of the American Civil Liberties Union. This strong support of workers was passed on to Ward's two daughters, Nanda Ward and Robin Ward Savage; I discovered this legacy during an incident that took place when I was invited to the family's summer camp in Canada one year. Nanda had met me at the nearest airport, which was located in Sault Sainte Marie, Ontario. On our long car drive to Lonely Lake, Nanda pulled over for gas before she noticed a

handful of workers raising signs in an obvious labor strike. It was not clear what they were striking against—either the gas company or the owner of the station—but Nanda, without hesitation, backed out of the station immediately, commenting that she was raised to never cross a picket line.

The abundant use of text within the illustrations in *Vertigo* realigns the pictorial narrative closer to the genre of comics, the distinct media of words and pictures with which Ward was familiar as a boy, when he read the comics in the Sunday newspapers. Ironically, in 1934 the first comic book appeared on the newsstands: It was a 32-page collection of newspaper comics called *Famous Funnies*. Ralph M. Person, in a review of *Vertigo*, observed that Ward was "unshackling the picture from its past limitation to the single scene or event and opening up a brand new world as broad as the novel, poem or play and, in its purely visual aspects, as the picture on the stage." What Person did not know at the time was that he was describing what we today recognize as the graphic novel, which Ward was inching close to defining.

<div align="right">DAVID A. BERONÄ</div>

David A. Beronä is a woodcut novel historian, the author of *Wordless Books: The Original Graphic Novels* (2008), the Library Director at Plymouth State University, New Hampshire, and a member of the visiting faculty at the Center for Cartoon Studies, White River Junction, Vermont.

VERTIGO

THE GIRL

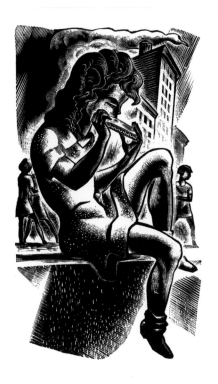

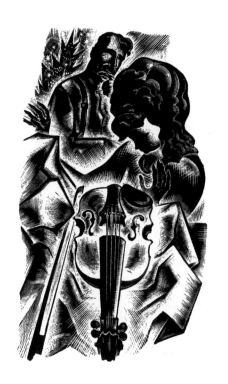

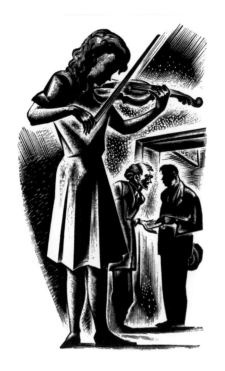

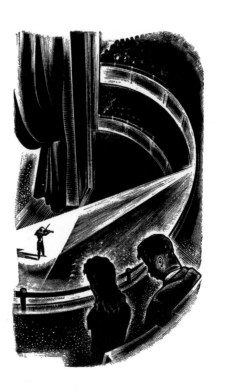

1929

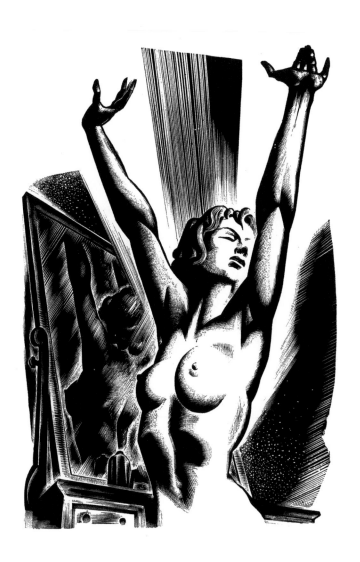

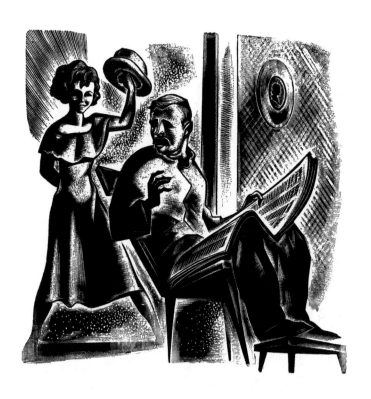

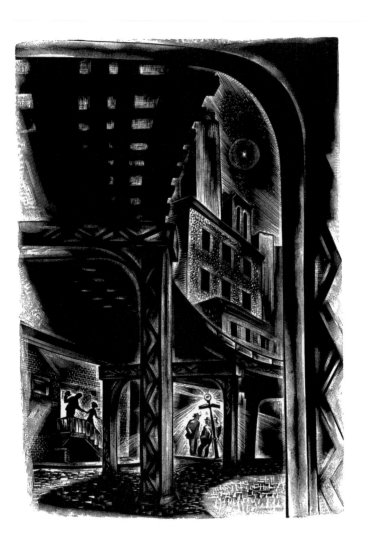

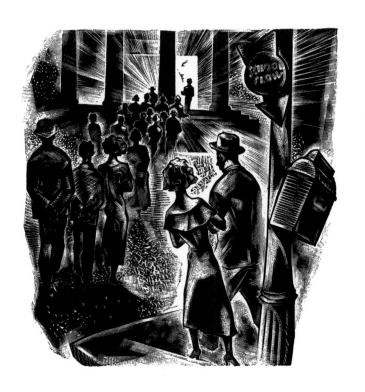

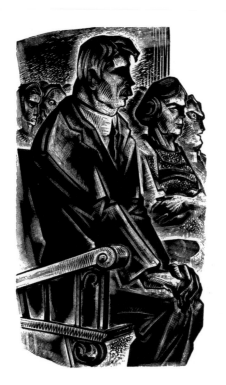

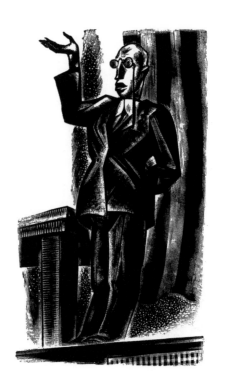

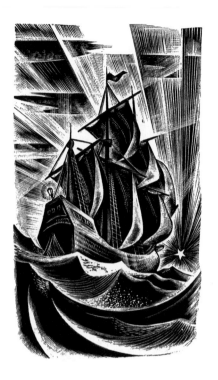

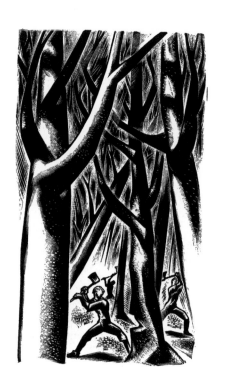

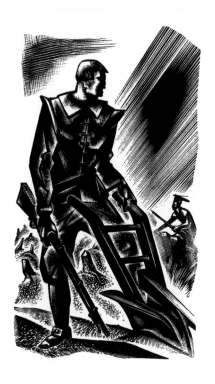

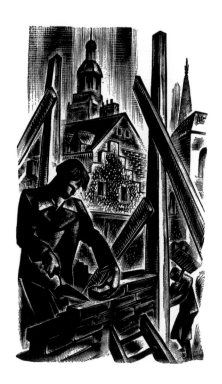

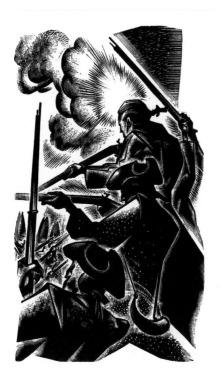

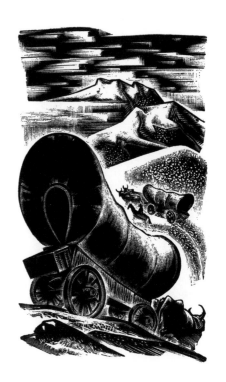

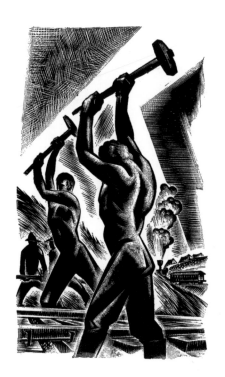

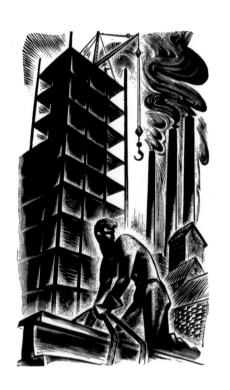

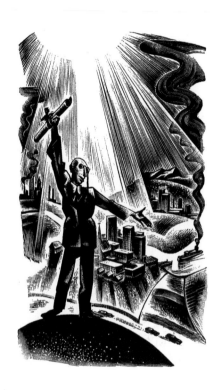

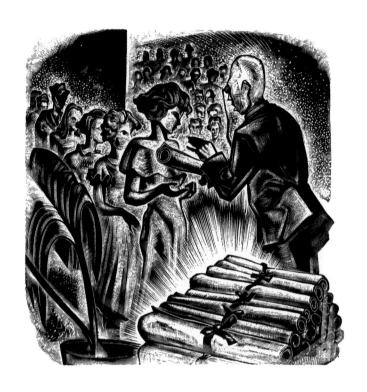

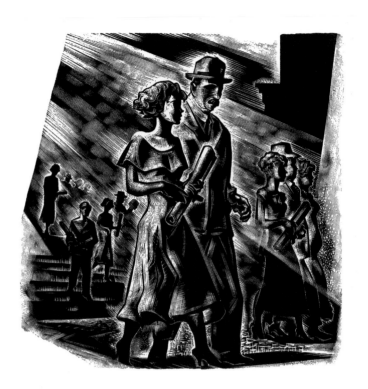

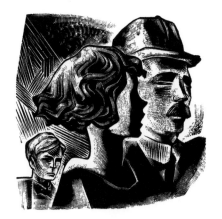

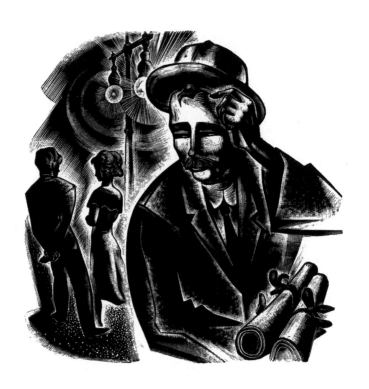

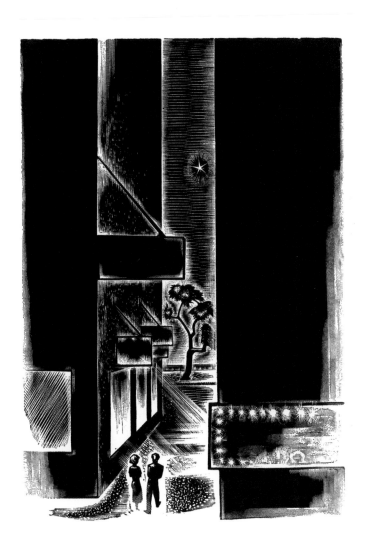

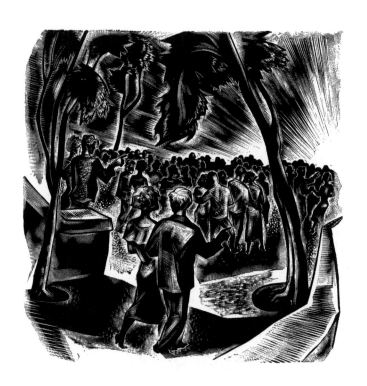

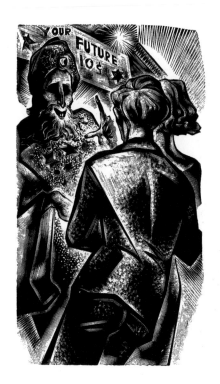

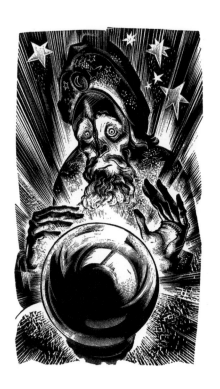

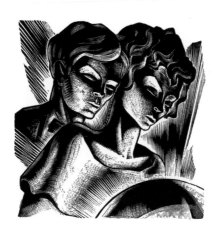

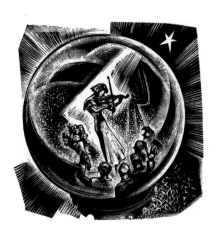

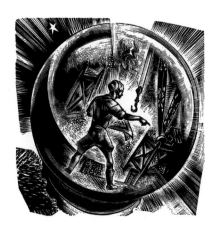

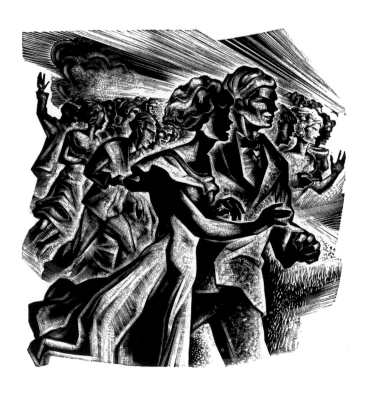

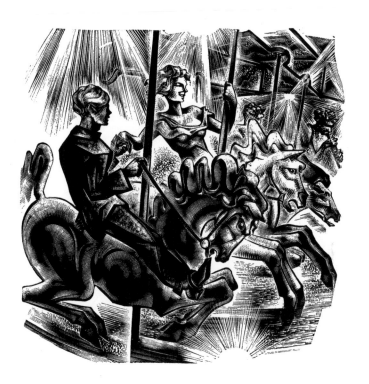

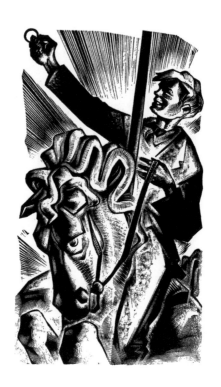

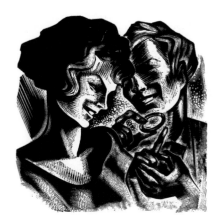

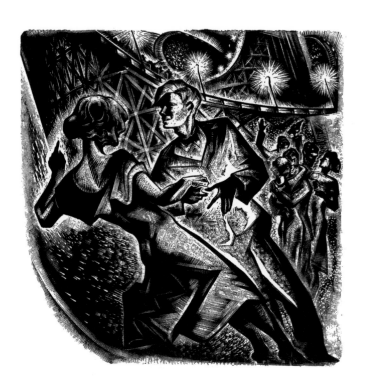

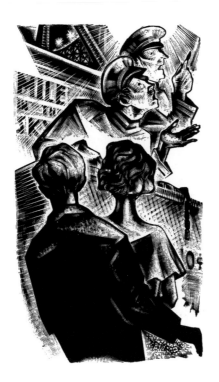

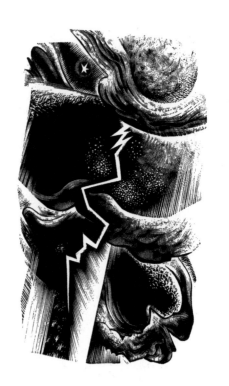

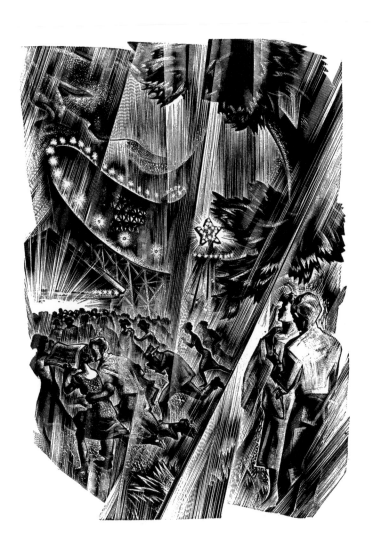

1930

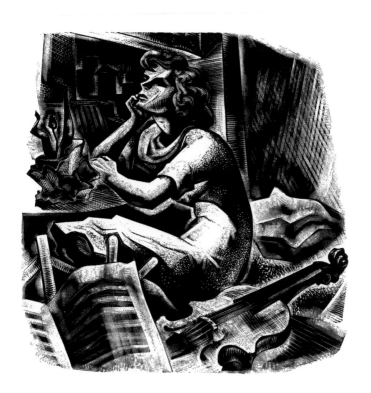

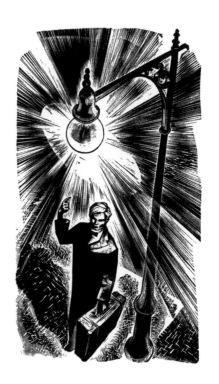

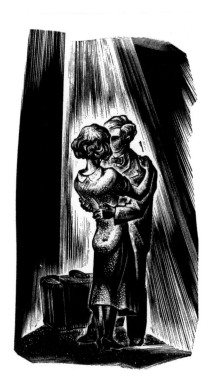

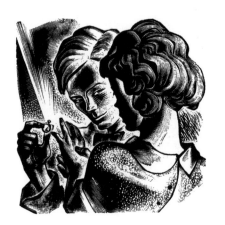

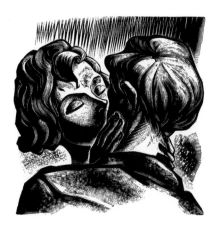

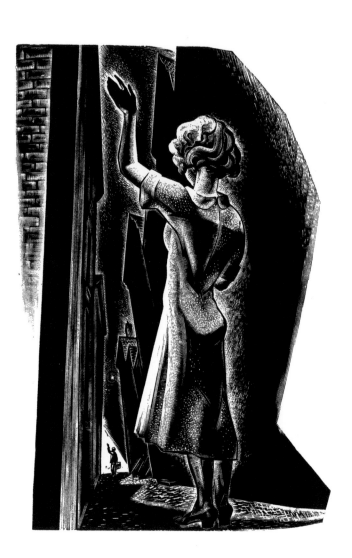

1931

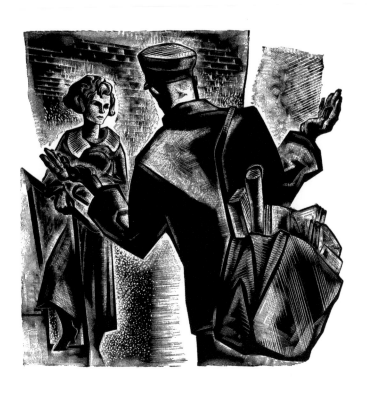

1932

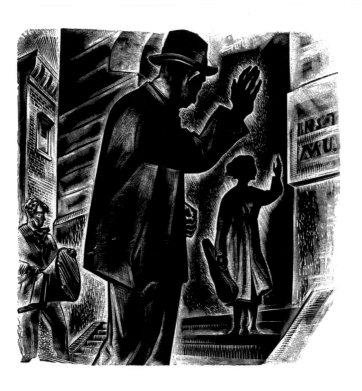

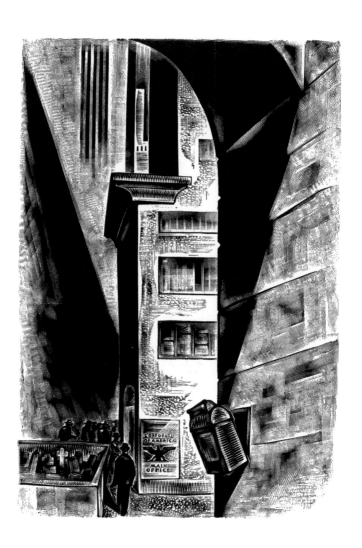

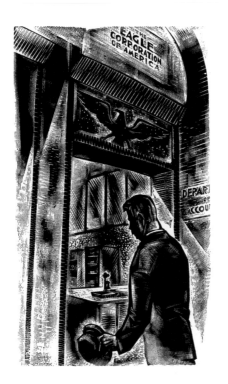

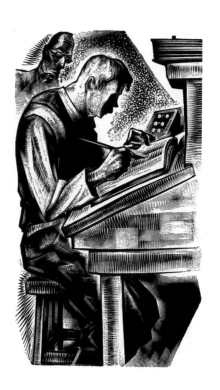

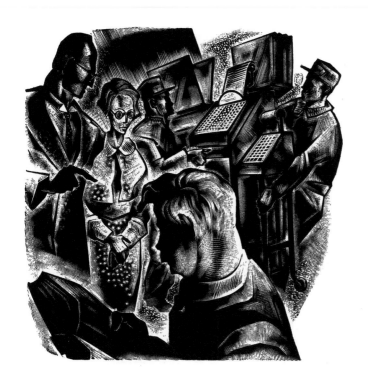

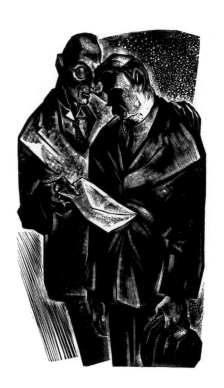

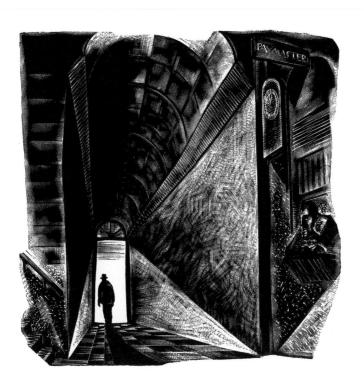

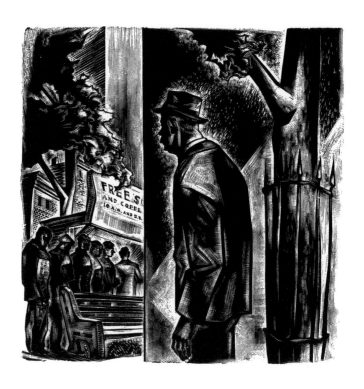

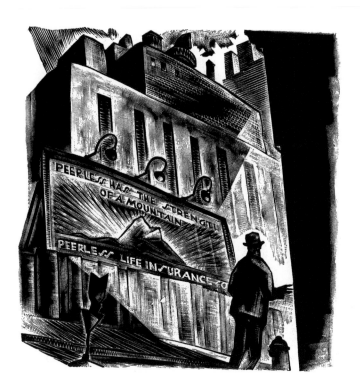

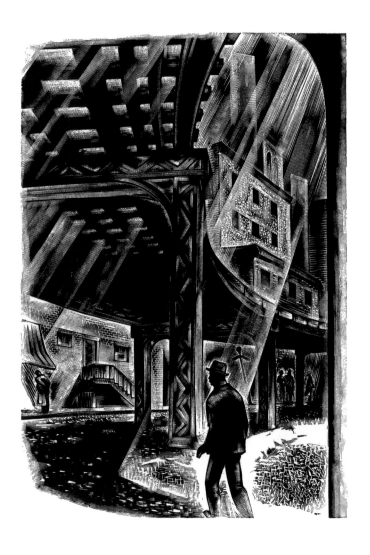

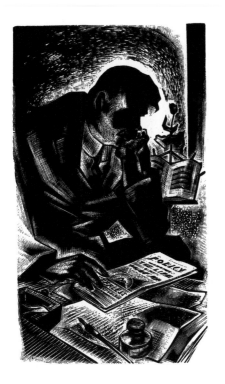

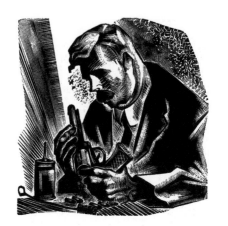

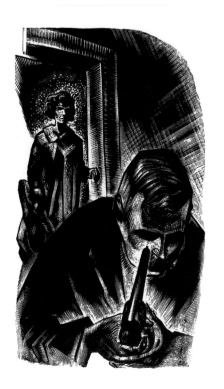

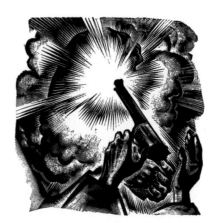

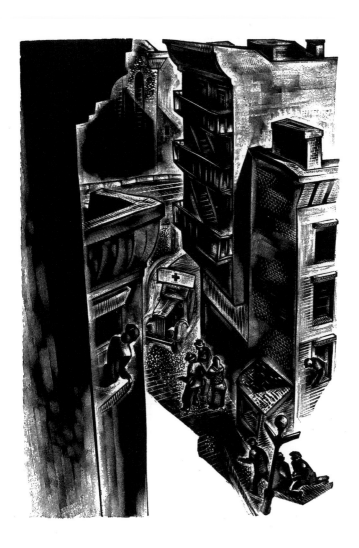

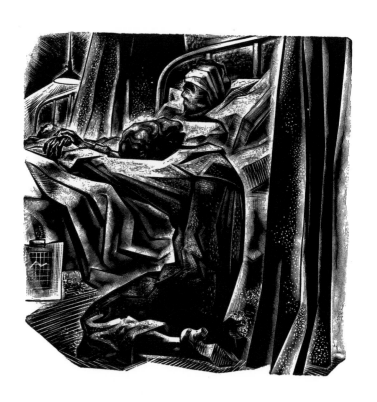

1933

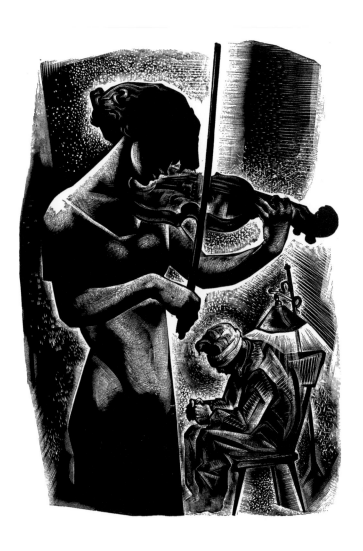

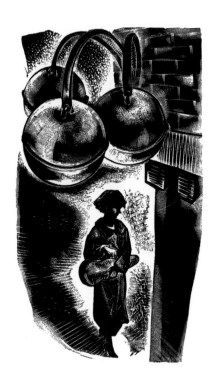

1934

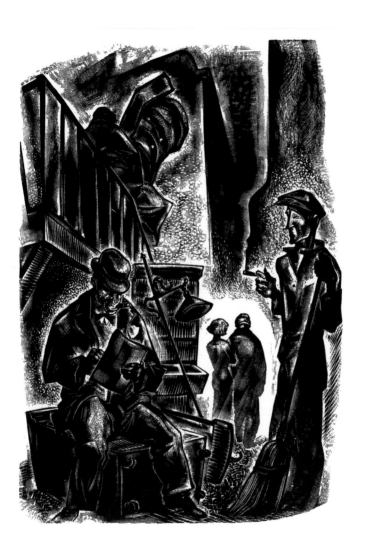

1935

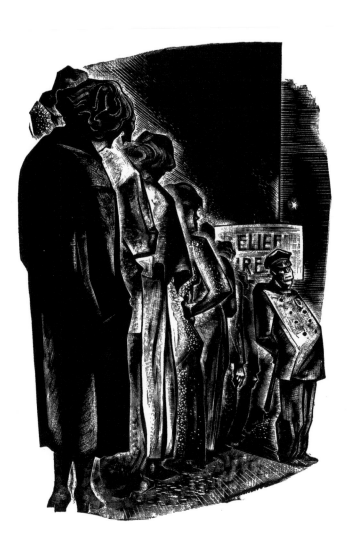

AN ELDERLY GENTLEMAN

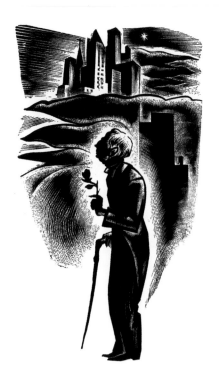

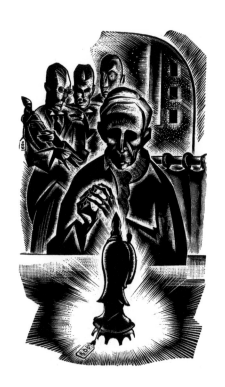

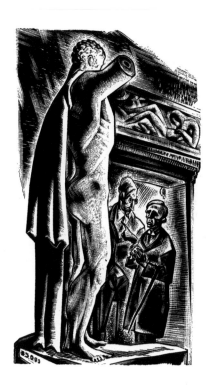

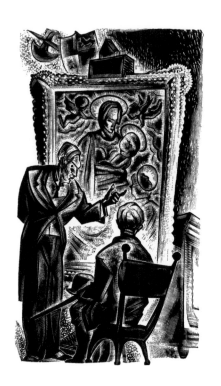

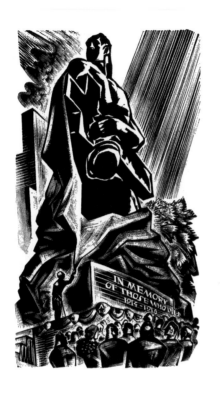

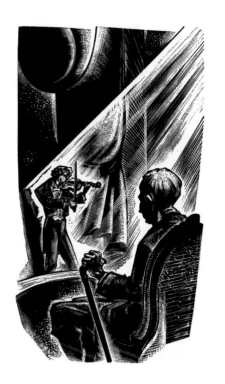

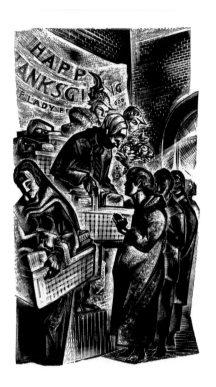

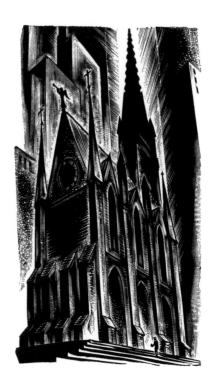

JANUARY

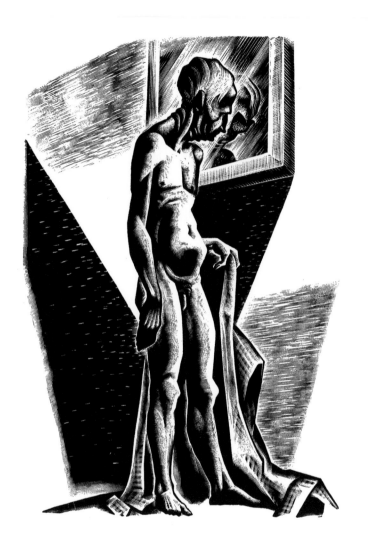

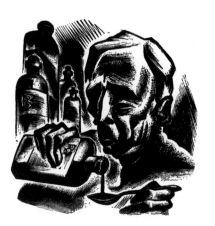

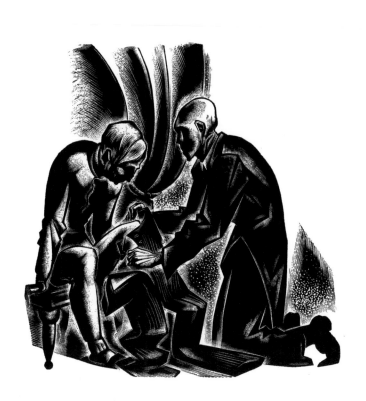

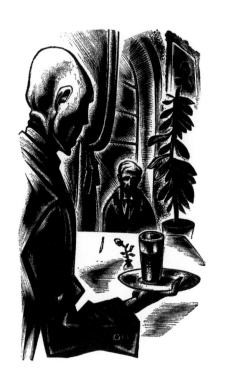

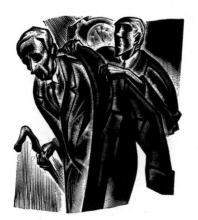

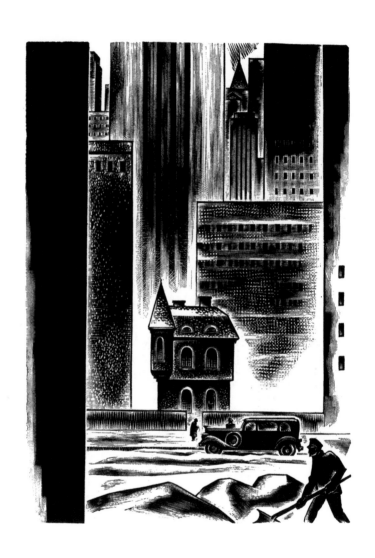

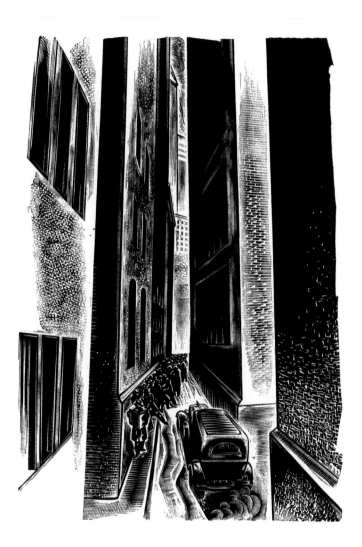

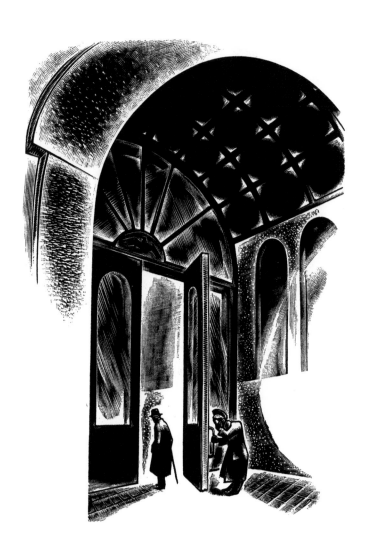

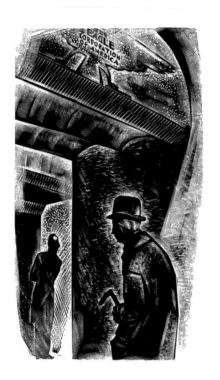

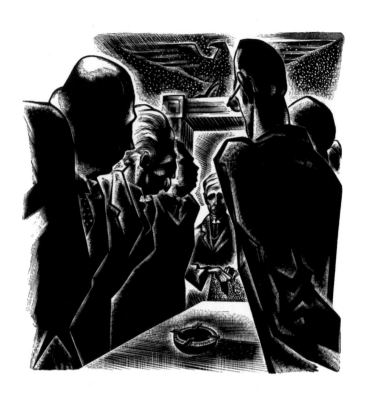

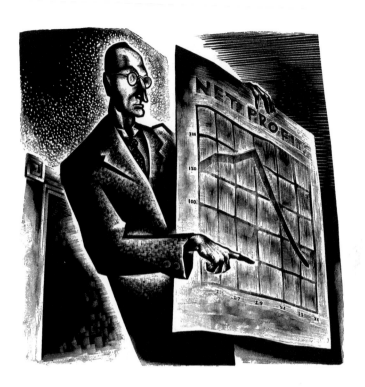

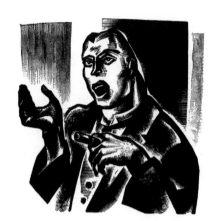

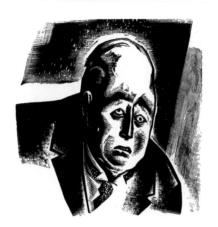

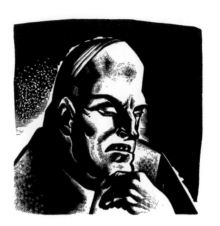

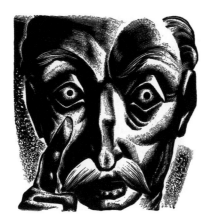

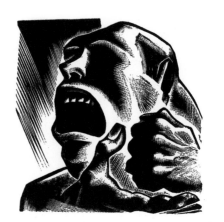

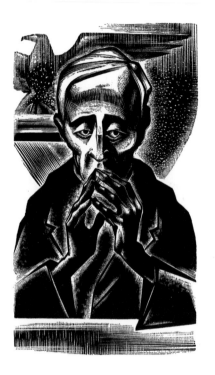

FEBRUARY

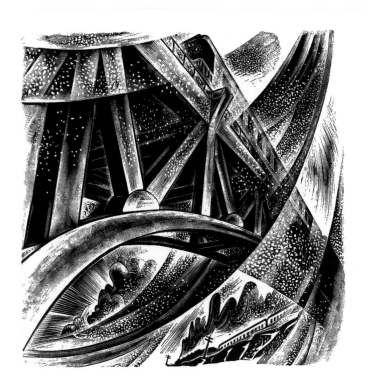

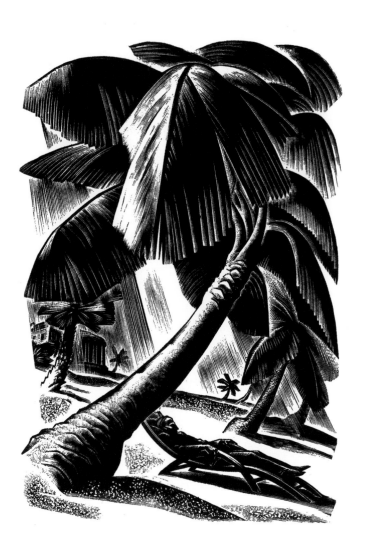

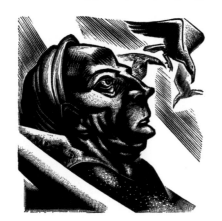

MARCH

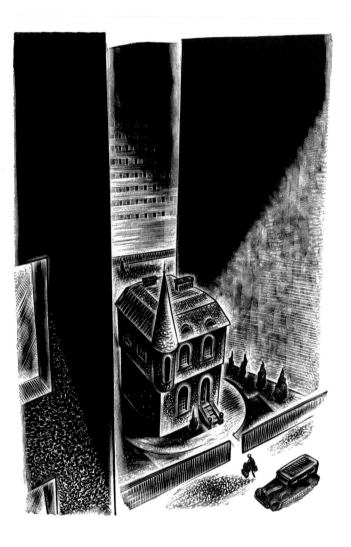

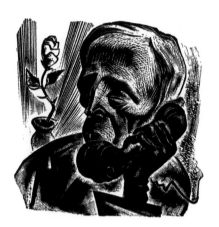

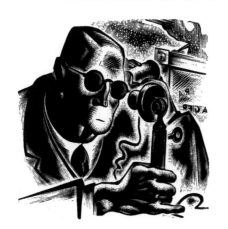

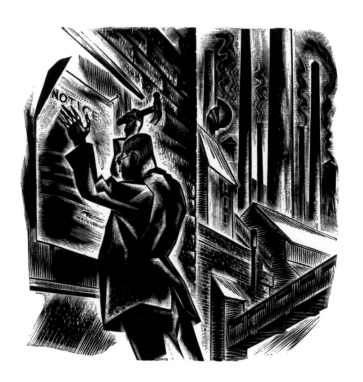

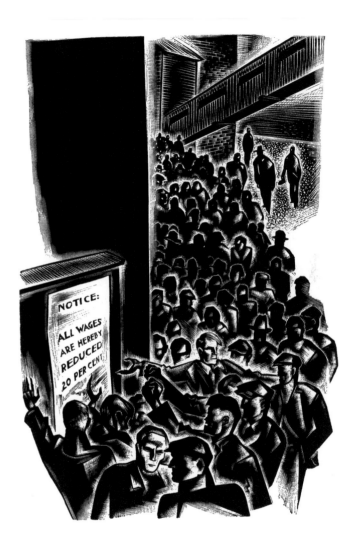

APRIL

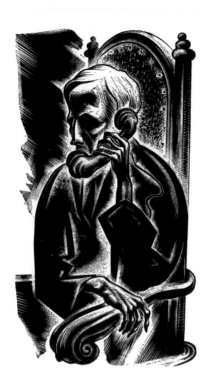

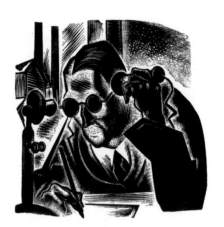

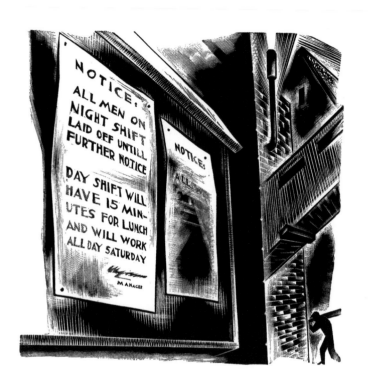

MAY

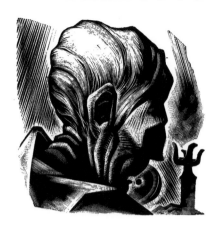

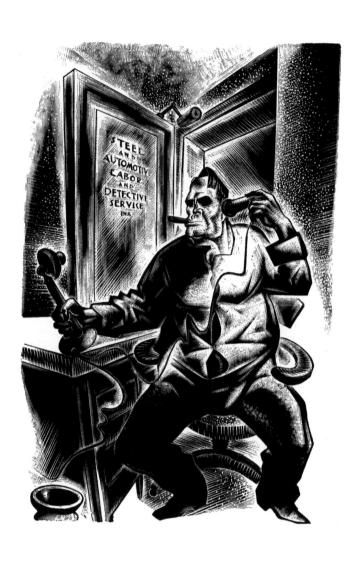

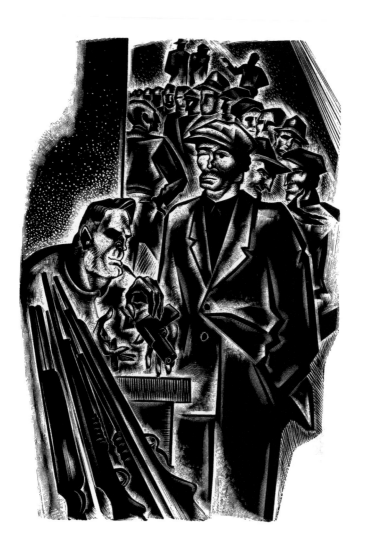

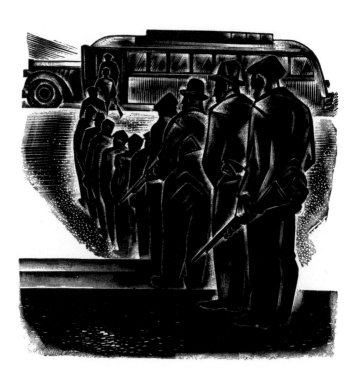

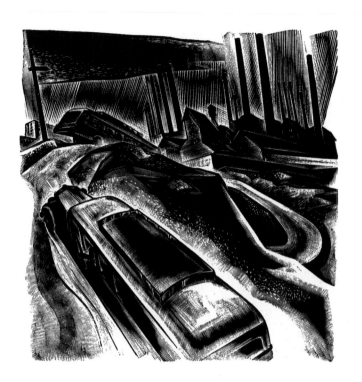

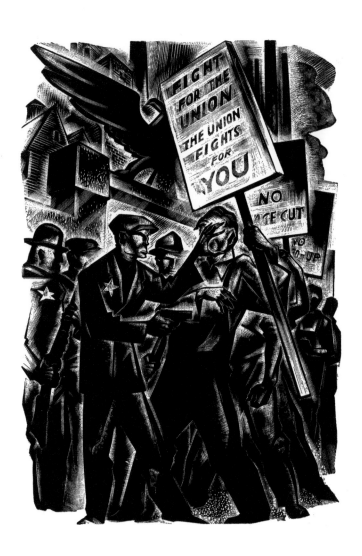

JUNE

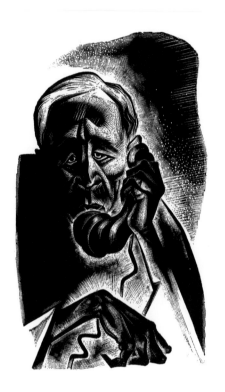

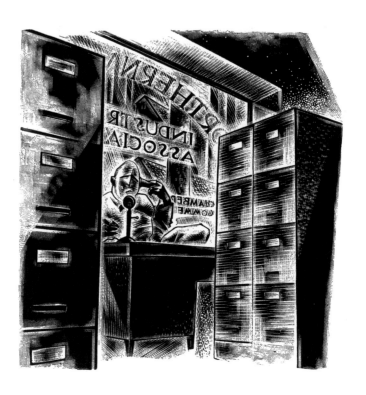

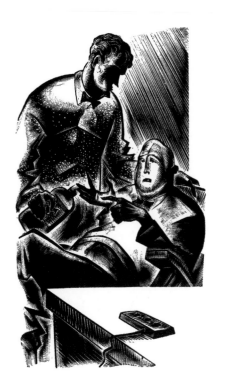

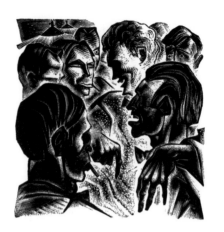

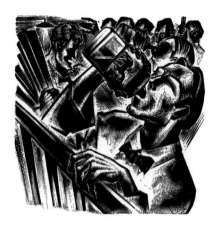

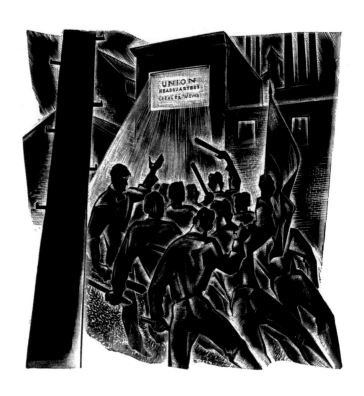

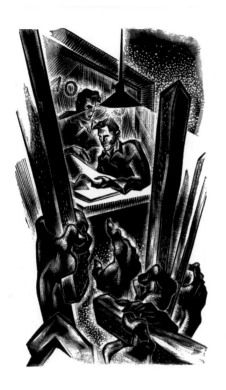

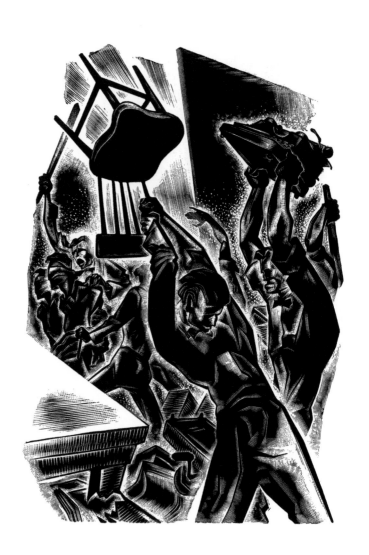

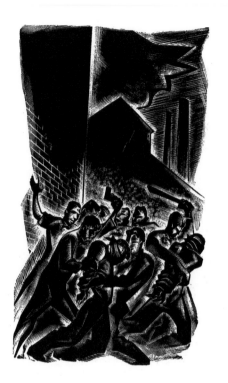

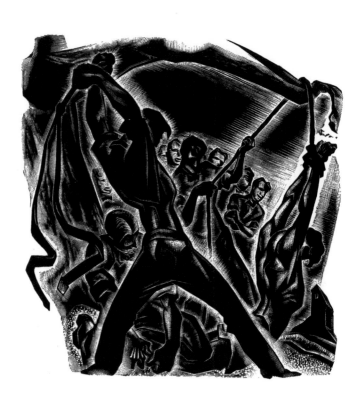

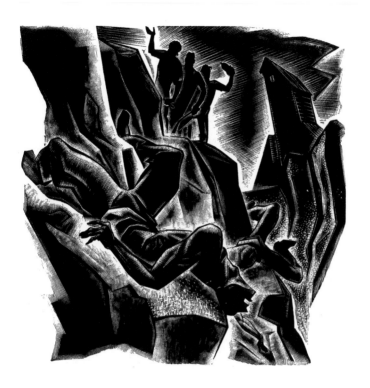

JULY

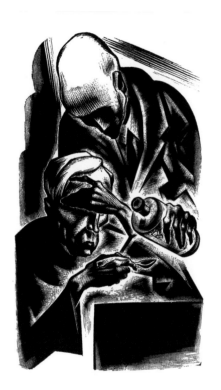

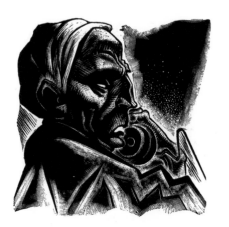

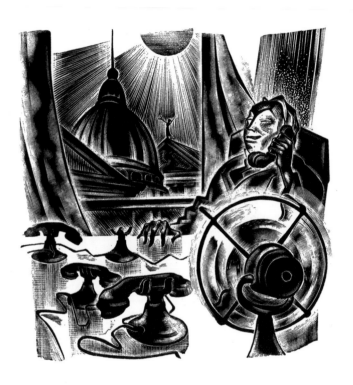

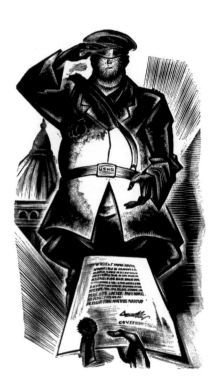

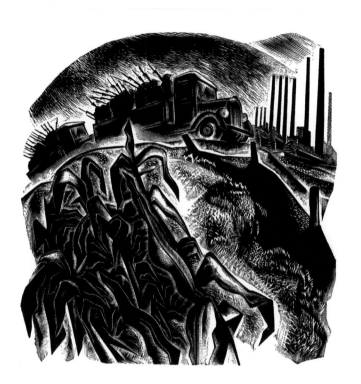

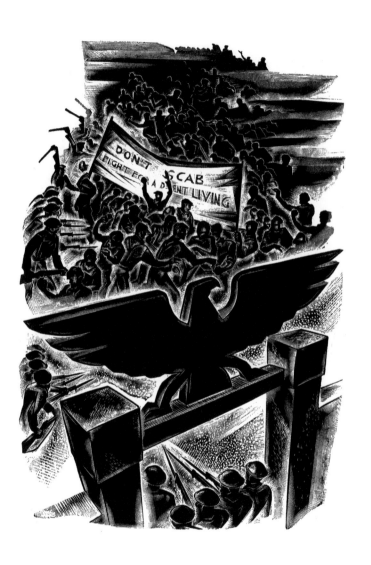

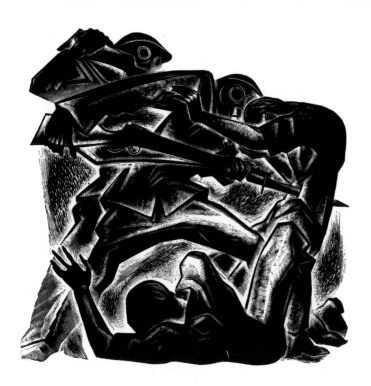

AUGUST

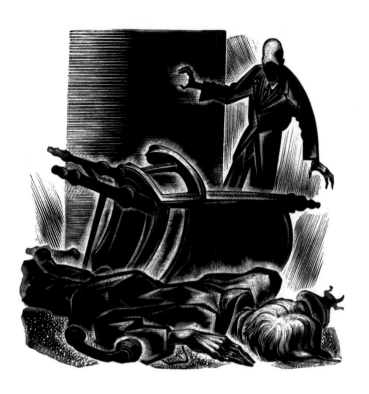

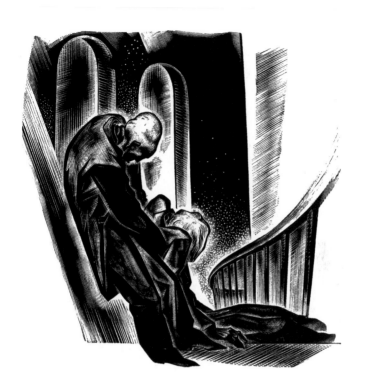

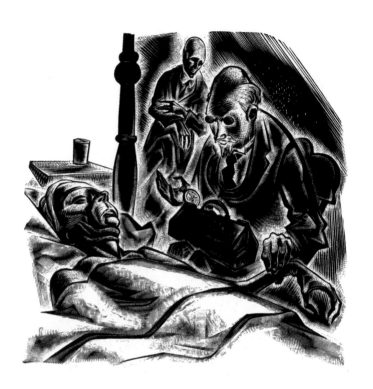

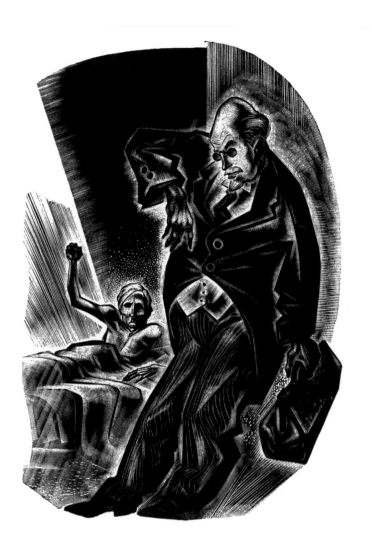

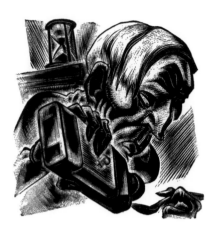

SEPTEMBER

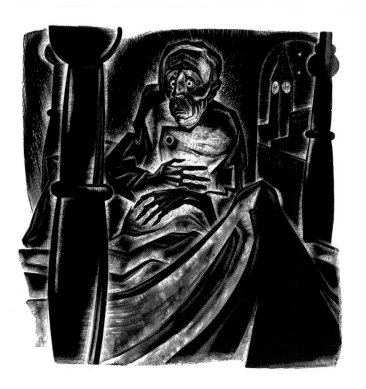

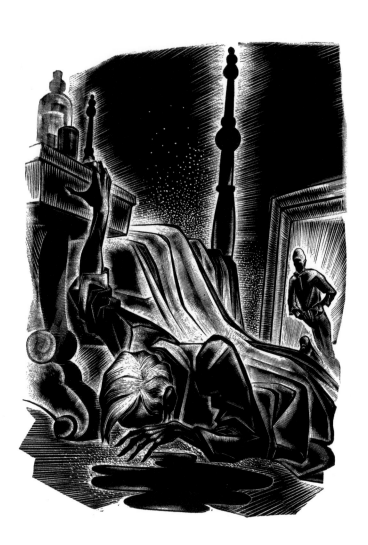

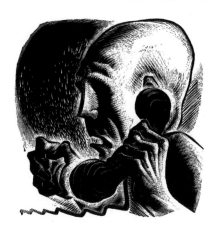

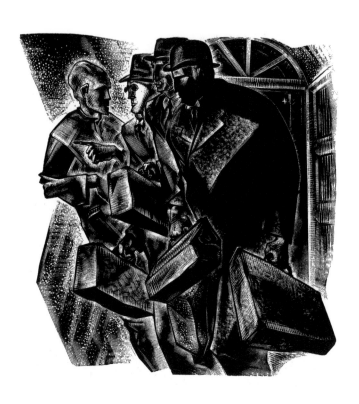

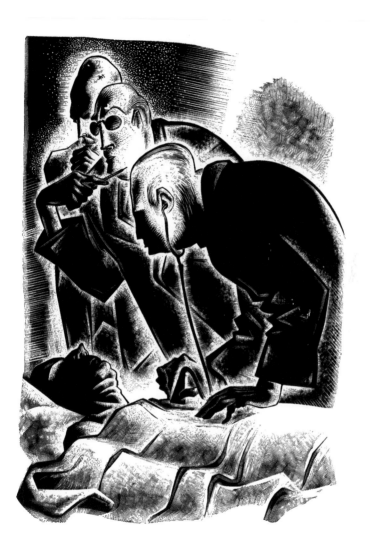

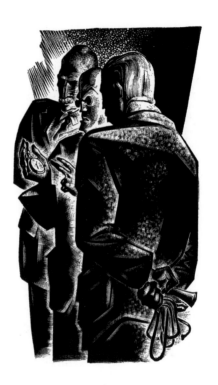

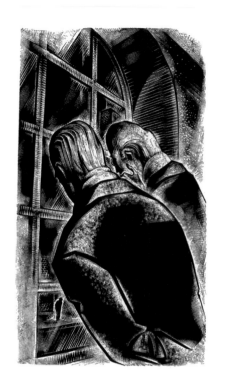

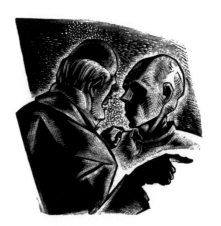

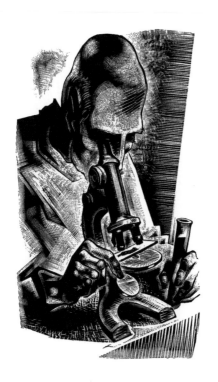

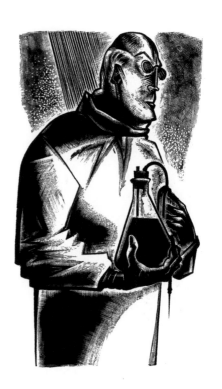

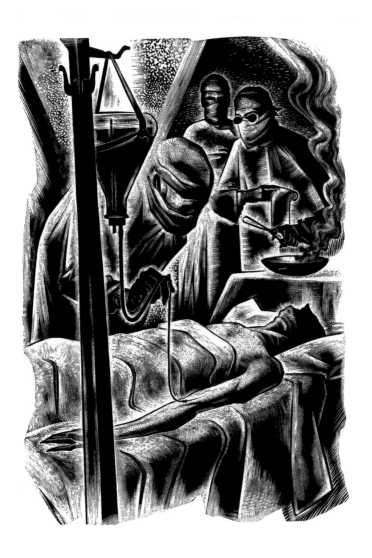

OCTOBER

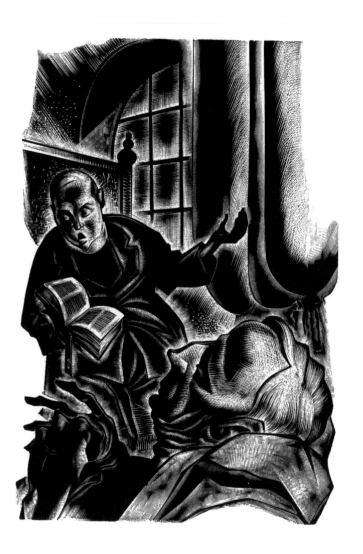

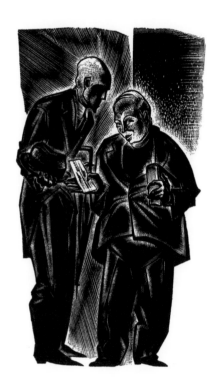

NOVEMBER

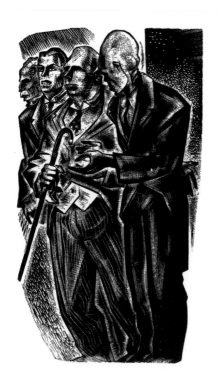

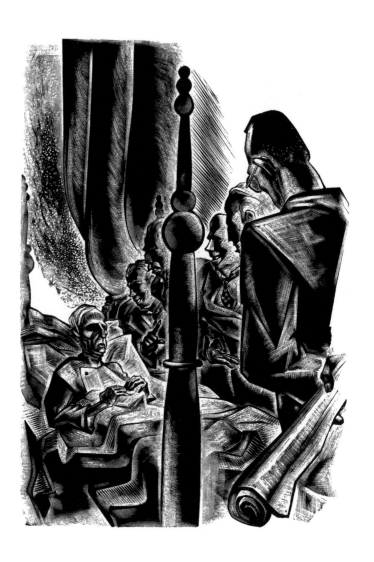

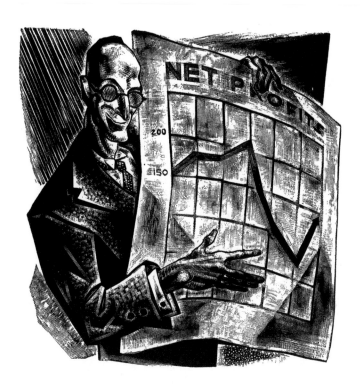

DECEMBER

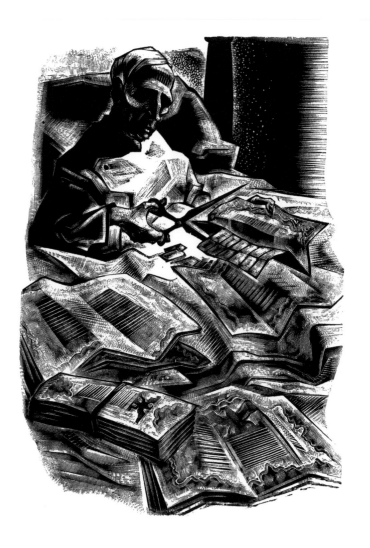

THE BOY

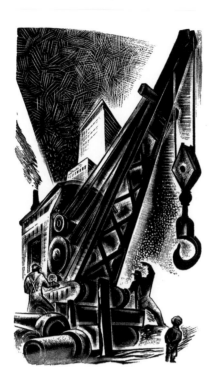

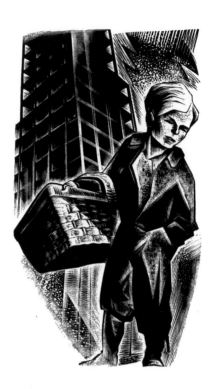

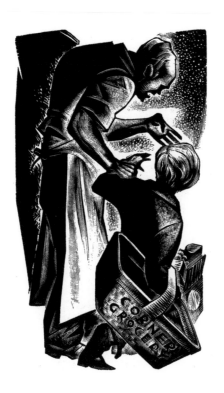

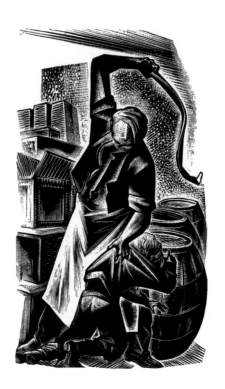

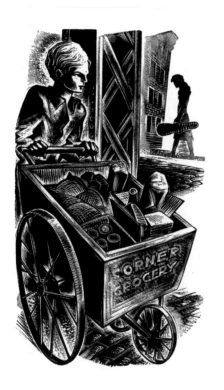

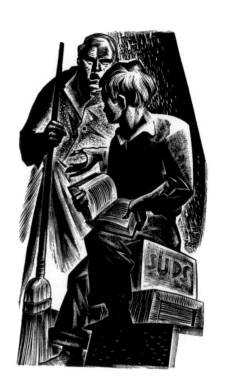

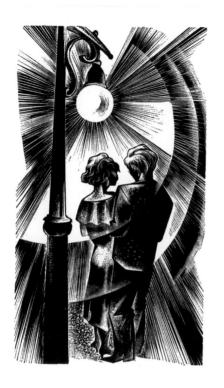

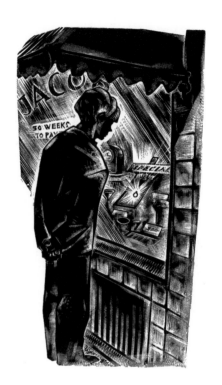

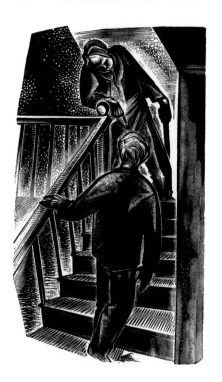

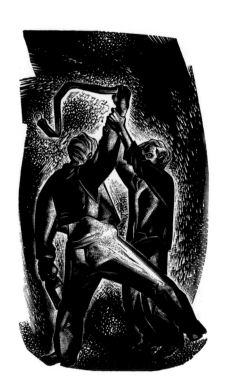

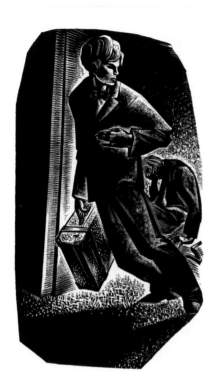

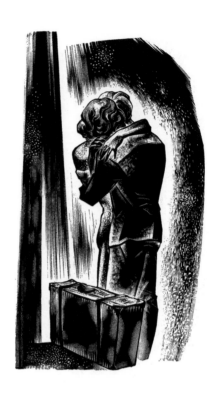

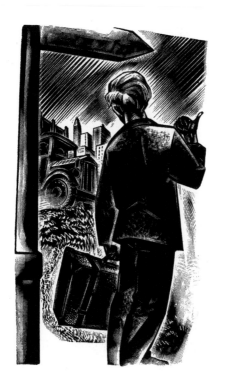

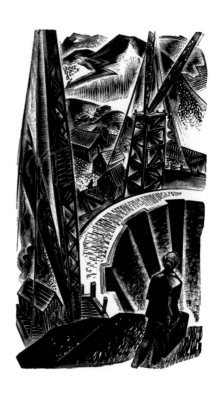

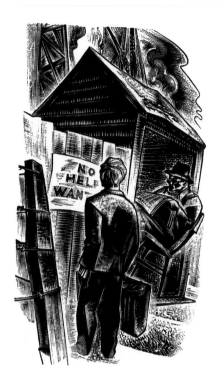

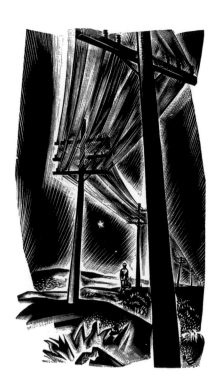

MONDAY

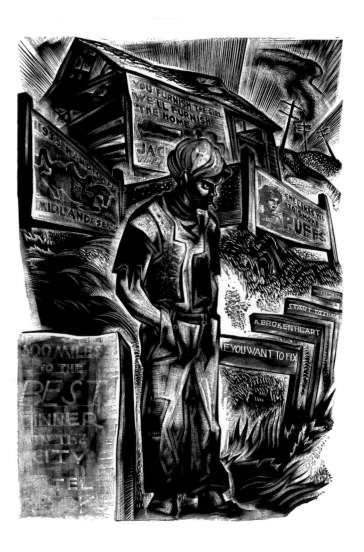

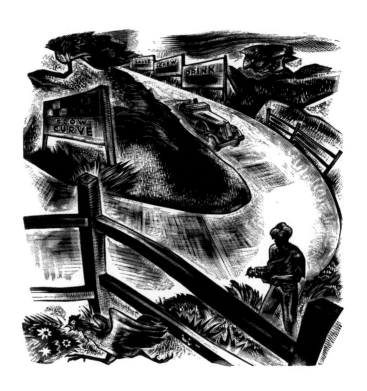

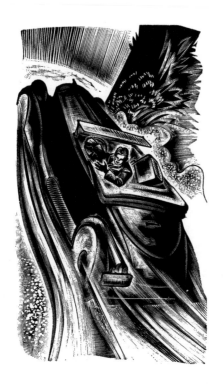

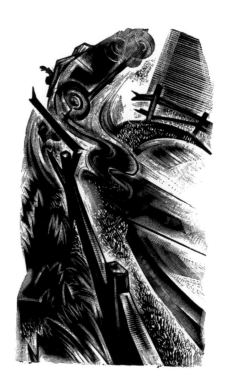

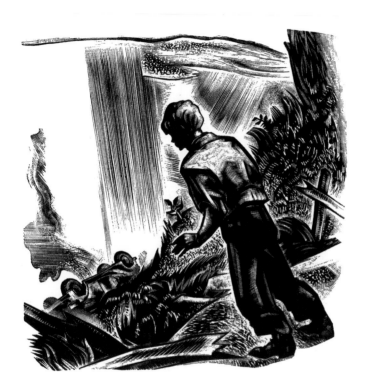

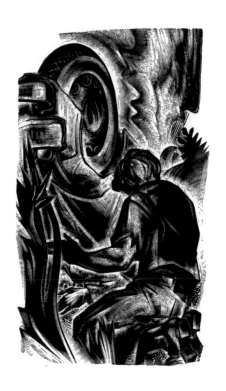

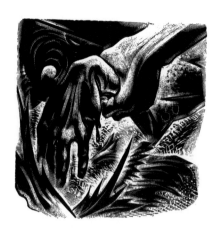

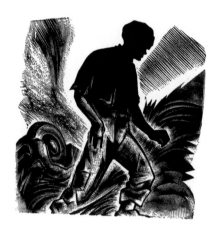

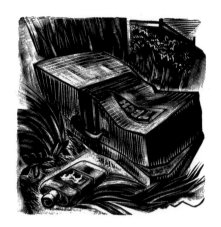

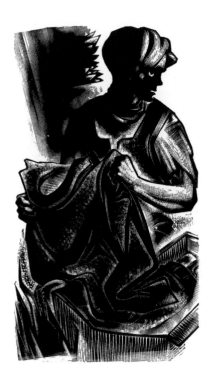

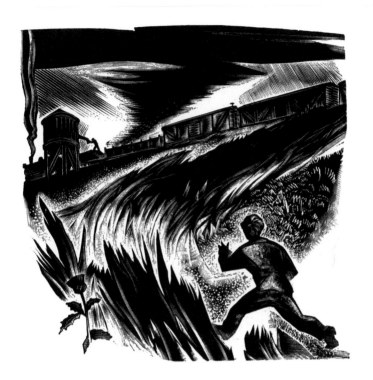

TUESDAY

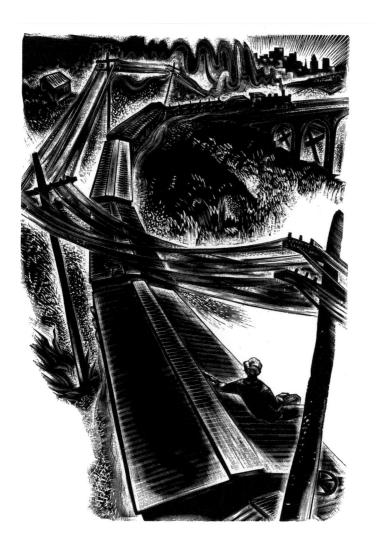

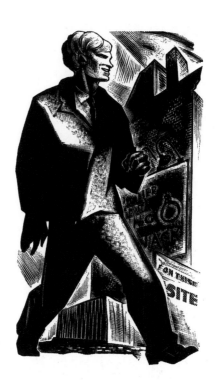

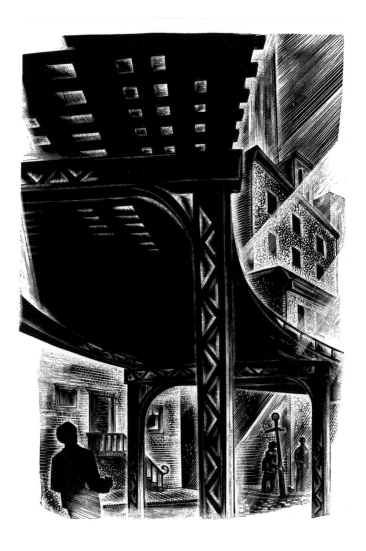

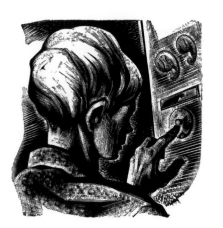

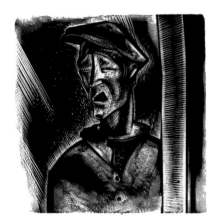

WEDNESDAY

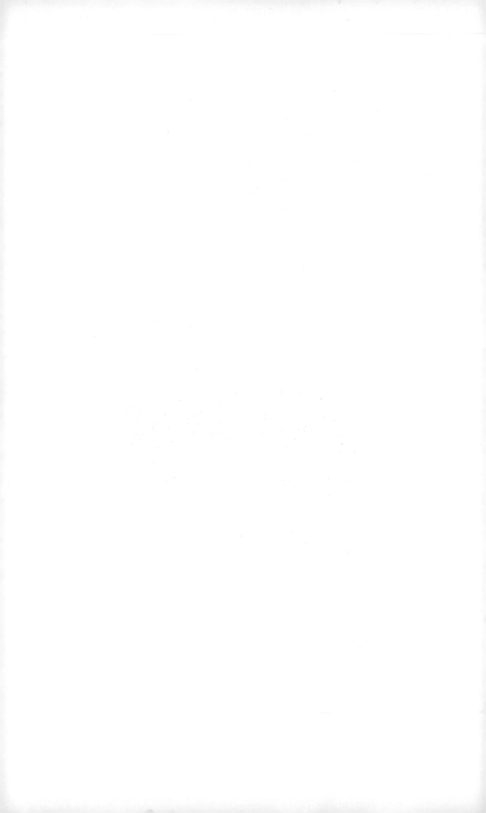

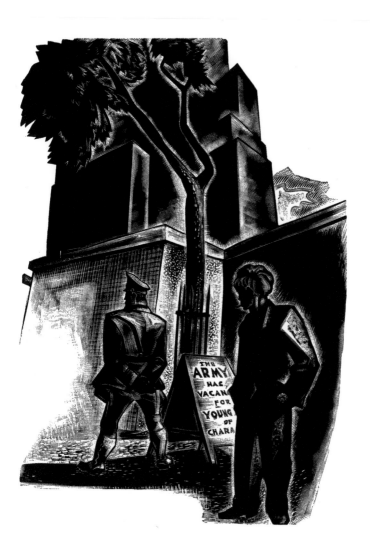

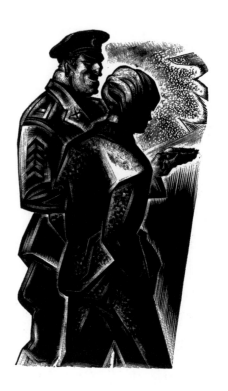

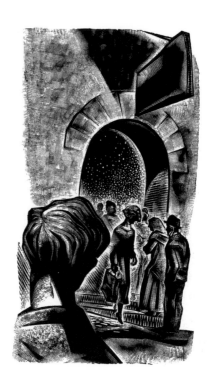

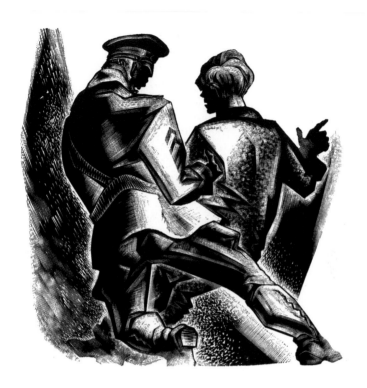

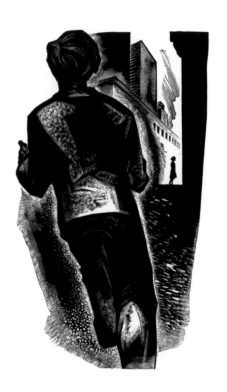

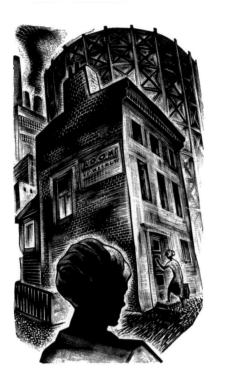

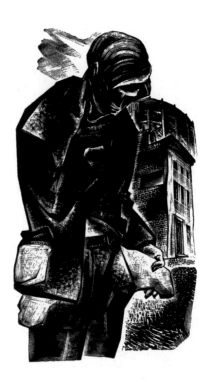

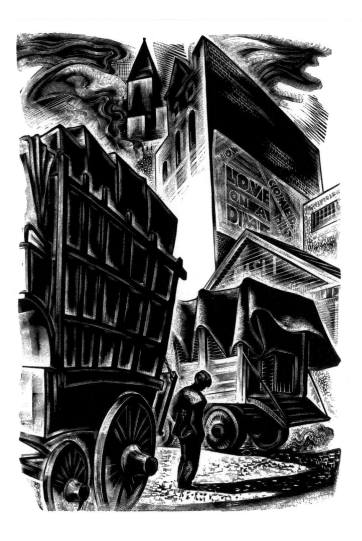

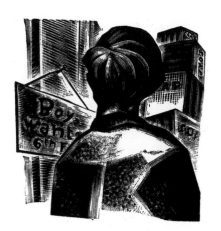

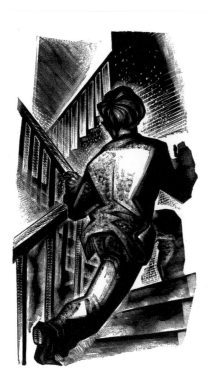

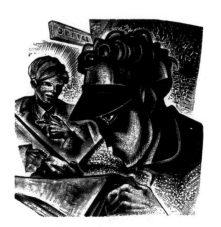

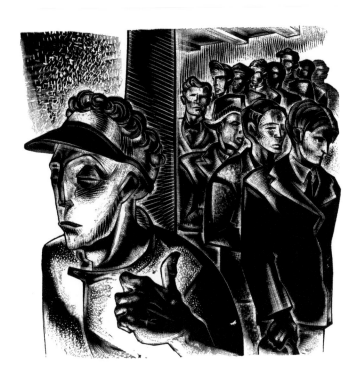

THURSDAY

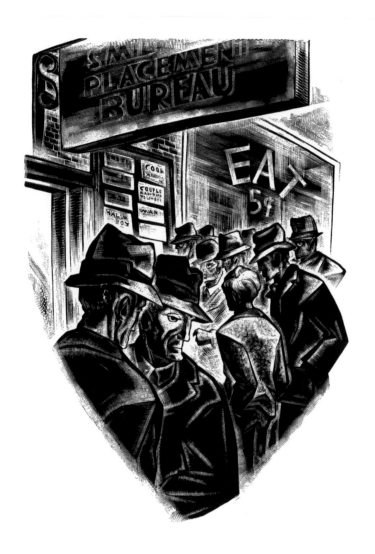

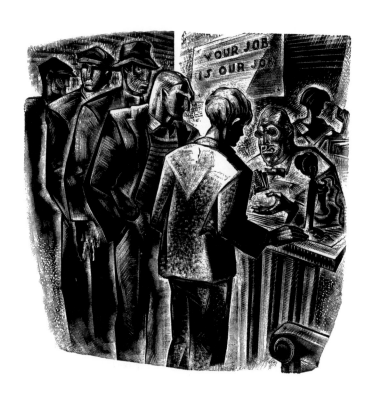

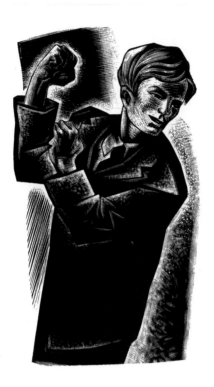

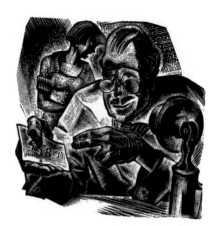

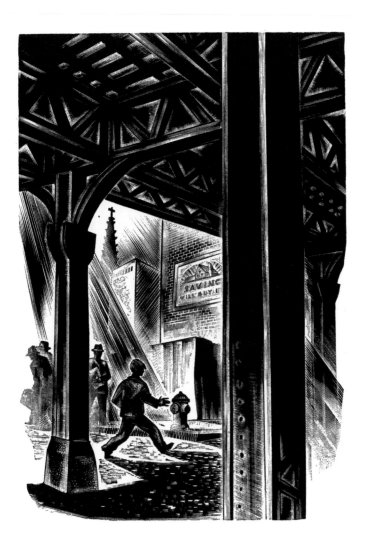

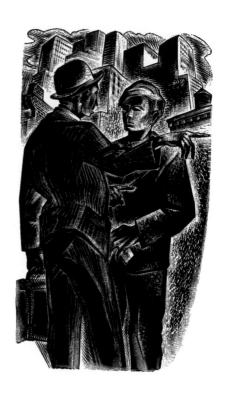

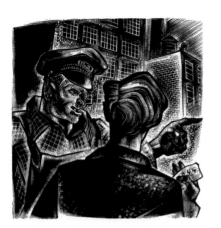

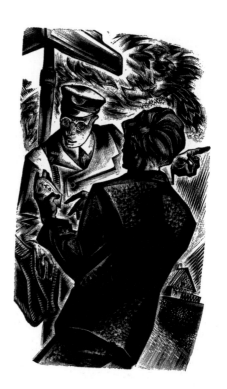

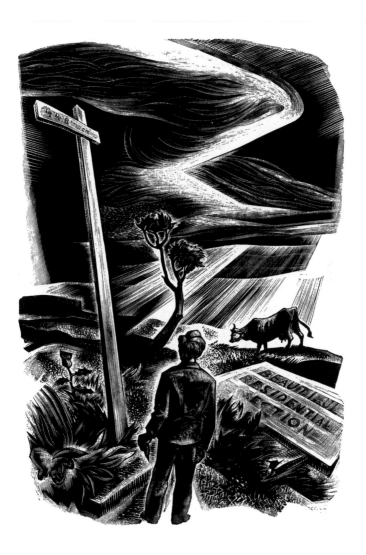

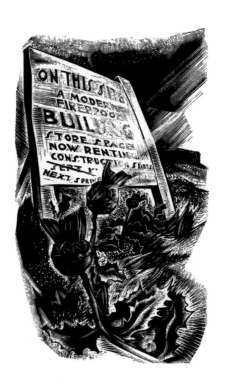

FRIDAY

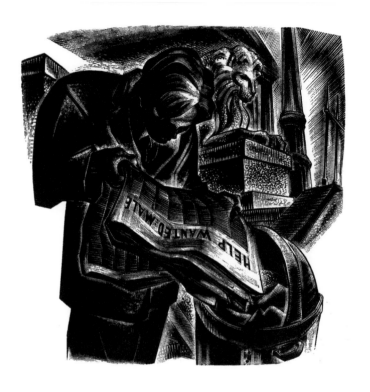

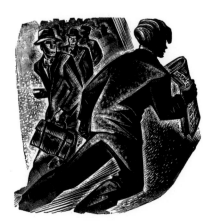

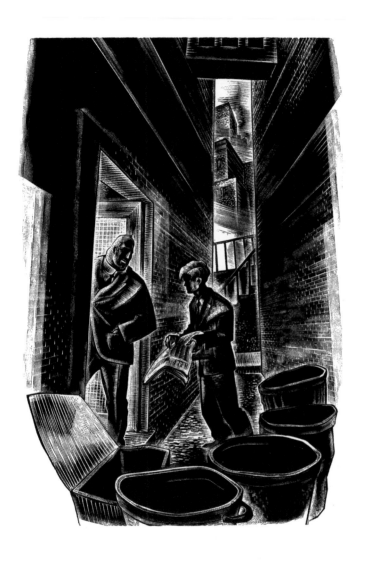

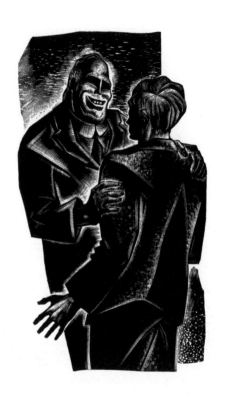

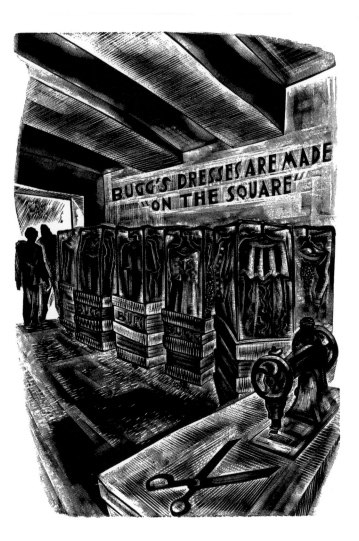

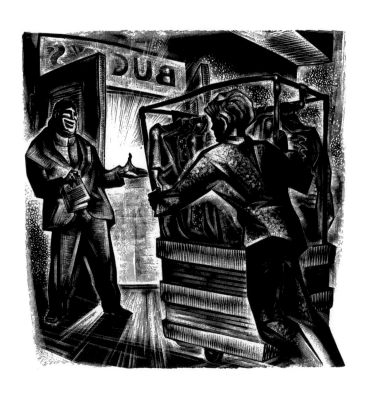

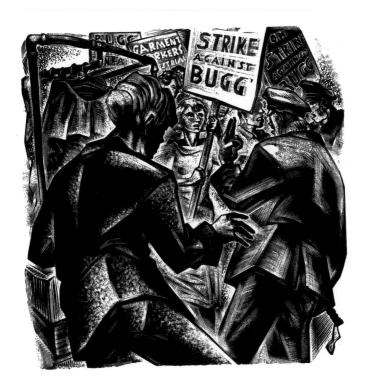

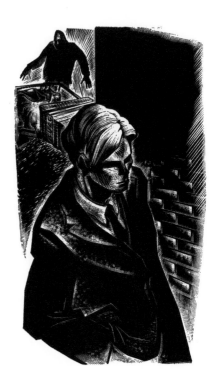

SATURDAY

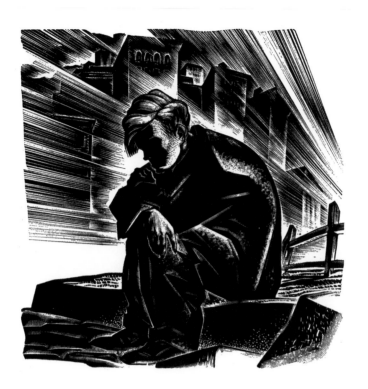

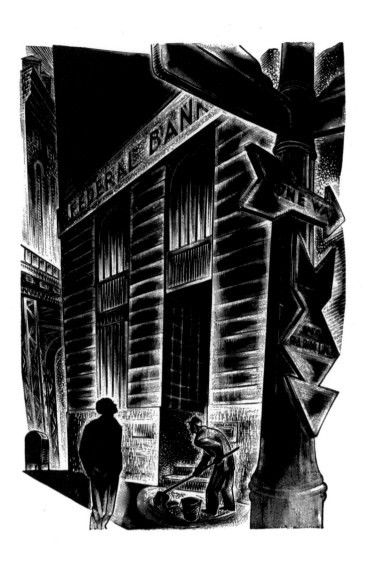

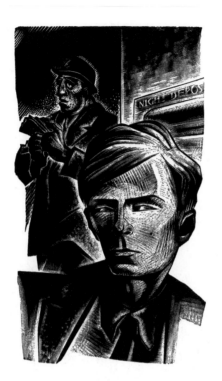

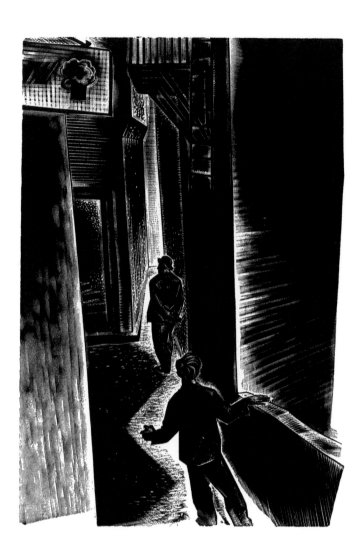

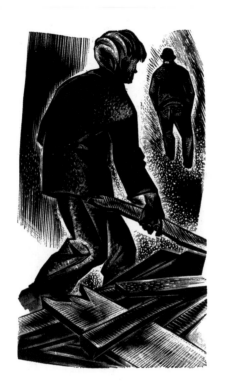

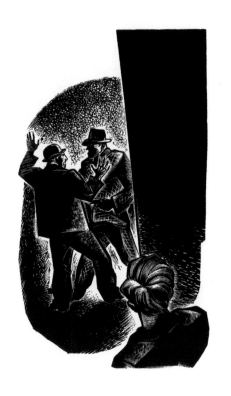

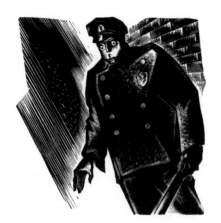

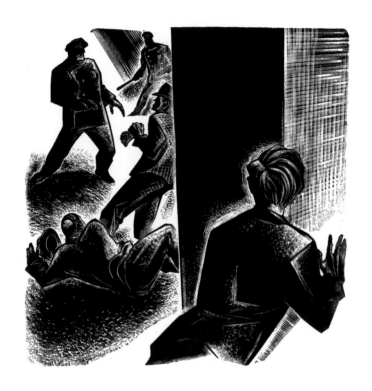

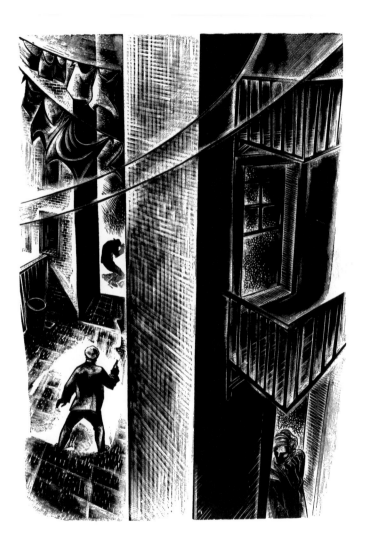

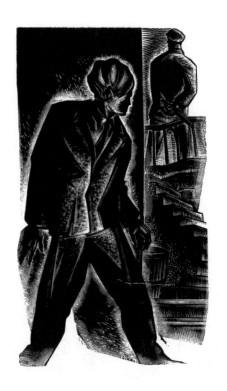

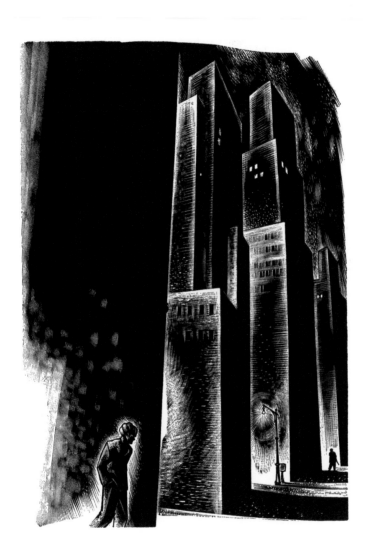

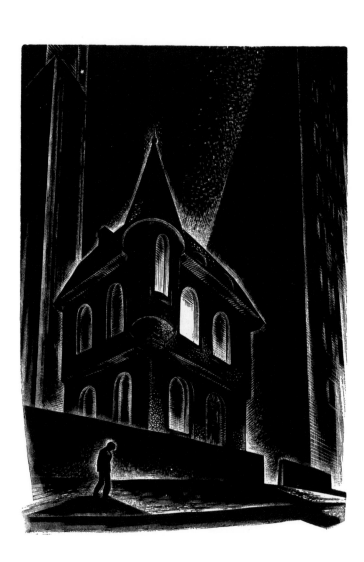

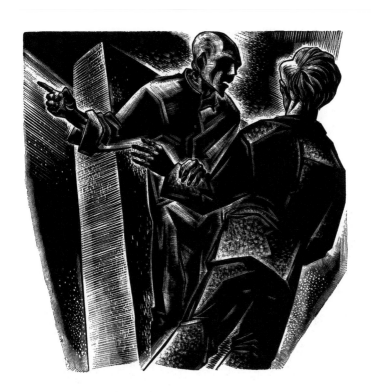

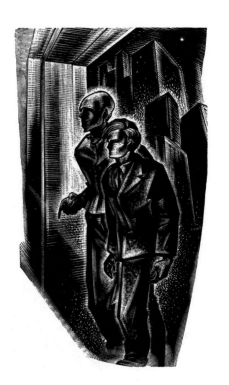

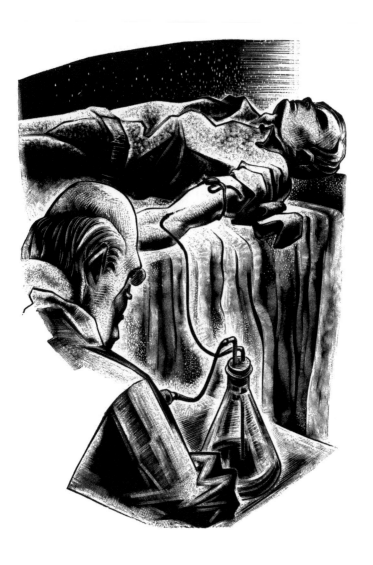

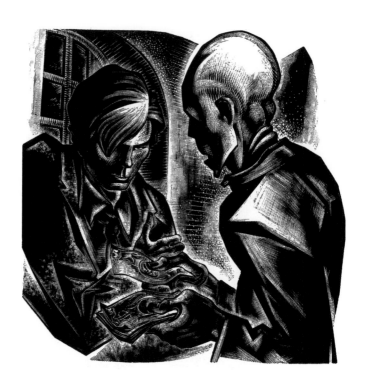

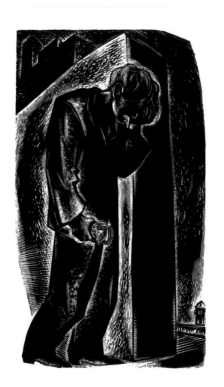

SUNDAY

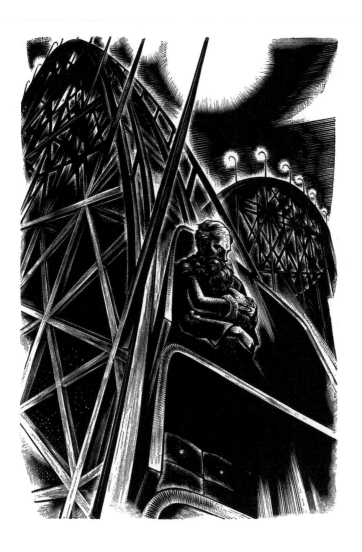